I Feel That

I Feel That

a quote collection for all the feels

CHRISTINA SCOTCH

A TarcherPerigee Book

tarcherperigee
An imprint of Penguin Random House LLC
penguinrandomhouse.com

Most TarcherPerigee books are available at special quantity discounts for bulk purchase for sales promotions, premiums, fund-raising, and educational needs. Special books or book excerpts also can be created to fit specific needs. For details, write: SpecialMarkets@penguinrandomhouse.com.

Hardcover ISBN: 9780593419427
Ebook ISBN: 9780593419434

Printed in China
1 3 5 7 9 10 8 6 4 2

Book design by Christina Scotch

To everyone who has been there, too

Contents

Introduction

Do you often find yourself crying at the end of a Disney movie for no apparent reason? Is it hard for you to tell from one moment to the next whether you're happy, sad, or hungry? Do you constantly feel as though everyone else is accomplishing a million things and you're just trying to get through the day without having a nervous breakdown? Well, *ding, ding, ding* I do, too.

Welcome to *I Feel That*.

To me, quotes have always been a magical, universal language that has the ability to say, in just a few words, "I've been there, too." They are a quick, powerful way of conveying the variety of feelings and emotions we all experience while reminding us we're not the only ones. There's no better feeling than reading a quote that describes exactly what you're going through and realizing that someone else has been there before and gotten through it.

Now, if there's one thing that can ruin a great quote, it's some black-and-white Times New Roman text, with or without a large animal pictured in the background, and sadly, so many of my favorite quotes have suffered this fate. That's why in 2018, I put my (very beginner) graphic designer cap on and created the thing I wanted to see in the world with an Instagram page called Quotes by Christie. Three "How to Use Adobe Illustrator" YouTube videos and an extensive Pinterest board later, I set

out on a mission to create an account dedicated to quotes, phrases, and words designed in bold, beautiful colors and fonts that amplified, not diluted, the message being shared.

I would have never predicted the journey that ensued, but that little idea has indeed changed my life. What began as a fun way to improve my graphic design skills and share inspiring messages with my family and friends has turned into a community of diverse people, united in our shared goal of just getting through this thing called life . . . one quote at a time. Now that I know I'm not the only one whose entire life could be changed by a good quote, I've put together a specially curated collection of my all-time favorite quotes to help you with all of your feels, in a format that can't be hacked or double-tapped.

I think it's safe to say that no one has discovered the secret to a life devoid of emotion. (If you have, please contact me ASAP.) So rather than trying to fight every feeling, I invite you instead to lean into them. Let yourself feel it all—the good, the bad, and the ugly.

The following quotes come from all different kinds of people, from all walks of life. Some are well-known, some are lesser-known, others are unknown, and a few are from yours truly. As you open this book after a heartbreak, when you're dealing with a disappointment, or when you just can't seem to get out of bed, I hope you find comfort and peace in knowing that every author—and every human being— could confidently look you in the eyes and say, "I feel that." And if they've gotten through it, who's to say you can't, too?

I Feel That

1

Motivation

I Want to Lie in Bed
and Watch *Gossip Girl* Reruns All Day

Some days I feel like I could write the sequel to *Hamilton* and win *The Great British Bake Off*. Other days—and these happen far more frequently—I struggle to put on a sports bra, and it feels like heating up my Trader Joe's frozen burrito is a big commitment. **YOU MIGHT BE HAVING ONE OF THOSE SPORTS BRA/ FROZEN BURRITO DAYS.** And I feel that. In my case, my barrier to motivation has always been my fear of failure. I'm constantly asking myself, "What's the point if I can't be the best? If I can't do it perfectly, why do it at all?" Case in point, let's take it back to five-year-old Christie. My French father wanted my siblings and me to learn the language at a young age, so we went to an all-French-speaking preschool. One day, a couple of weeks into school, the teacher called my mother to tell her I had yet to utter a word in class. When my mother approached me about this, I told her that until I learned to speak French perfectly, I would not speak in class. She kindly

walked me through my failed logic, and I eventually mustered the courage to speak my less-than-perfect French in class, but looking back, it's interesting to see how this situation applies to so many life experiences. Ultimately, my desire to speak the language perfectly was actually what was preventing me from getting to the level of all the other kids. They were willing to fail, to mispronounce or misuse some words, but with every mistake, they learned something and got better. Whereas I, by not even trying, saved myself from potential "failure" but also prevented myself from learning and growing in ways that would lead to my eventual success. Such is the case with just about every worthy goal in life. It's so much easier to never try at all than it is to take the chance and give it your all, especially when success is not guaranteed. As the saying goes, however, "Nothing great ever comes from comfort zones." It's our willingness to make mistakes, get messy, get uncomfortable, and do hard things that ultimately leads to the greatest rewards. Failure is not the end of success but merely a necessary step toward it. The key is just to start!

Unknown

YOU ARE FAR TOO SMART TO BE THE ONLY THING STANDING IN YOUR WAY.

JENNIFER J. FREEMAN

Many of life's failures are people who did not realize how close they were to success when they gave up.

Thomas A. Edison

IT DOESN'T MATTER HOW THIS LOOKS TO OTHER PEOPLE. IF THIS IS SOMETHING YOU GOTTA DO, THEN YOU DO IT. FIGHTERS FIGHT.

SYLVESTER STALLONE

Reminder: life does not come with a one-size-fits-all timeline.

Christie

ASK YOURSELF WHAT IS REALLY IMPORTANT AND THEN HAVE THE COURAGE TO BUILD YOUR LIFE AROUND YOUR ANSWER.

LEE L. JAMPOLSKY

You can also fail at what you don't want, so you might as well take a chance on doing what you love.

Jim Carrey

The most grown-up thing you can do is fail at things you care about.

Samantha McIntyre

BEFORE SOMETHING GREAT HAPPENS, EVERYTHING FALLS APART.

UNKNOWN

It's the Possibility of Having a Dream Come True That Makes Life Interesting.

Paulo Coelho

In between dreams and goals is a thing called life that must be lived and enjoyed.

Sid Caesar

The very next thing you need to be doing is the thing that terrifies you the most.

Eleanor Roosevelt

There is
never a right
time to do a
difficult thing.

John Porter

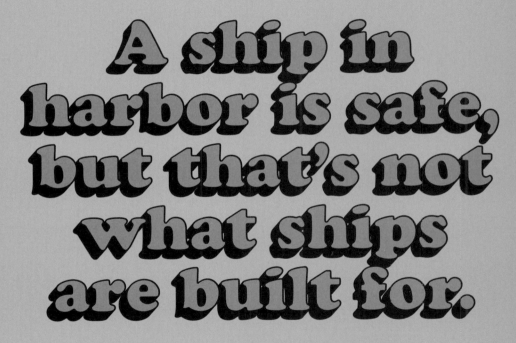

A ship in harbor is safe, but that's not what ships are built for.

John A. Shedd

I hope you're proud of yourself for the times you've said "yes," when all it meant was extra work for you and was seemingly helpful only to someone else.

Fred Rogers

Stop obsessing over how much further you have to go, and focus on how far you've come.

Christie

I BEGAN TO REALIZE HOW IMPORTANT IT WAS TO BE AN ENTHUSIAST IN LIFE. IF YOU ARE INTERESTED IN SOMETHING, NO MATTER WHAT IT IS, GO AT IT FULL SPEED AHEAD. EMBRACE IT WITH BOTH ARMS, HUG IT, LOVE IT, AND ABOVE ALL, BECOME PASSIONATE ABOUT IT. LUKEWARM IS NO GOOD. HOT IS NO GOOD, EITHER. WHITE HOT AND PASSIONATE IS THE ONLY THING TO BE.

ROALD DAHL

Competition

I'm Comparing Myself
to That Instagram Model Again

I wish I could say I am so self-actualized that I focus solely on my own self and never compare or compete with anyone . . . but I'm a graphic designer, not a saint. It seems that from a young age, competition is something that's ingrained in everything we do. As a kid, your intelligence talents, and accomplishments are all measured, not by how good you are at [fill in the blank], but by how much better you are at [fill in the blank] than your peers. And in adulthood, it gets even worse. **WHY IS IT THAT NO MATTER HOW GOOD WE HAVE IT, IT'S NEVER ENOUGH UNTIL WE HAVE IT BETTER THAN SOMEONE ELSE?** A prime culprit in this culture of competitiveness is my frenemy Instagram (and basically every other social media platform). When I first started Quotes by Christie, I had about five followers (shout-out to my family!), and I would be happy to get even ten likes on a post. I was posting and creating for the joy of it, with no regard for my follower or like

count. As I continued to grow, however, this changed. Even though I was now getting thousands of likes and followers instead of dozens, that wasn't good enough unless I got more likes than that other post or gained more followers than that other account. No matter how well things were going for me, my only measure of success became how much better they were going for me than for others. This toxic mindset plagued me for a long time, and I know I'm not the only one who has experienced this. It feels impossible nowadays not to compare every aspect of our lives to everyone else's, especially when their highlight reels are constantly being broadcast during our rehearsals. Here's a thought that has really helped me as I've struggled. It's a completely crazy, bonkers, totally insane idea, but what if there was room . . . for all of us to shine? What if someone else's beauty, success, or talent didn't take away from our own beauty, success, or talent? Well, I come bearing good news, my dear stranger-friends: it DOESN'T. No one can shine the way you do, but everyone can shine the way they do, and there's room for all of that light in this big ol' world! If we focused all the energy we put into competing with others into being our best selves, imagine what we could do. And once we know that there's room for everyone to be great, what if we also put some of that leftover energy (the portion saved from not comparing ourselves to every Instagram model) into helping others become their best selves? Well then, you shine, they shine, we all shine, and the world becomes a very, very bright place.

Just remember that sometimes, the way you think about a person isn't the way they actually are.

John Green

How your life feels is a lot more important than how it looks.

Unknown

NOBODY'S LIFE IS AS PERFECT AS THEY WANT YOU TO THINK IT IS.

CHRISTIE

IF YOU ARE INSECURE, GUESS WHAT? THE REST OF THE WORLD IS, TOO. DO NOT OVERESTIMATE THE COMPETITION AND UNDERESTIMATE YOURSELF. YOU ARE BETTER THAN YOU THINK.

TIM FERRISS

DON'T MEASURE YOUR PROGRESS USING SOMEONE ELSE'S RULER.

GRACE INK

Don't compare your life to others'. There's no comparison between the sun and the moon. They shine when it's their time.

Unknown

WOULD YOU LOVE YOURSELF IF YOU HAD NO ONE ELSE TO COMPARE YOURSELF TO?

CHRISTIE

WE DON'T SEE THINGS AS THEY ARE, WE SEE THEM AS WE ARE.

ANAÏS NIN

The only thing you'll lose by being real is something that's fake.

Unknown

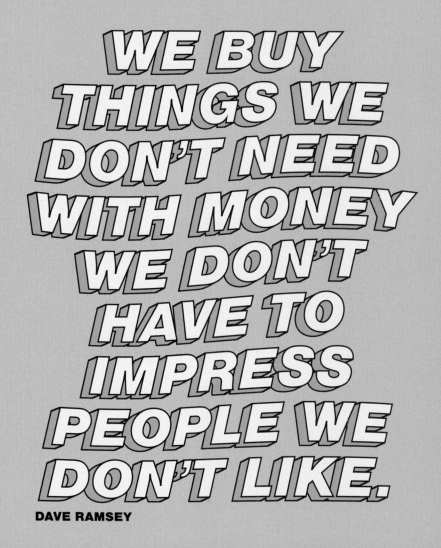

WE BUY THINGS WE DON'T NEED WITH MONEY WE DON'T HAVE TO IMPRESS PEOPLE WE DON'T LIKE.

DAVE RAMSEY

EVERYONE IS GOING THROUGH SOMETHING THEY DON'T TALK ABOUT.

CHRISTIE

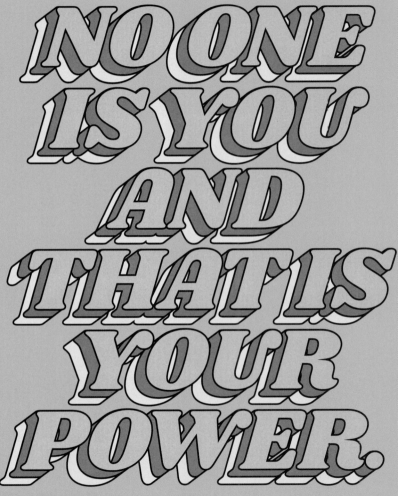

NO ONE IS YOU AND THAT IS YOUR POWER.

HELLOGIGGLES

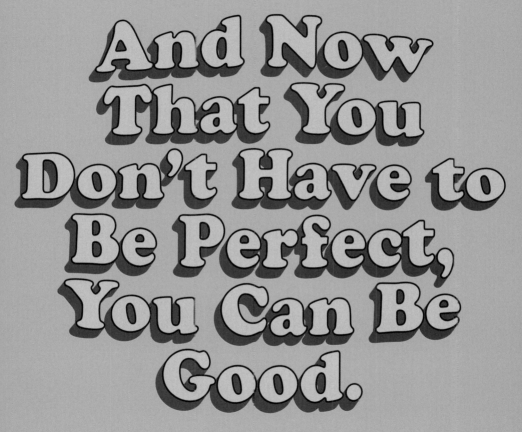

And Now That You Don't Have to Be Perfect, You Can Be Good.

John Steinbeck

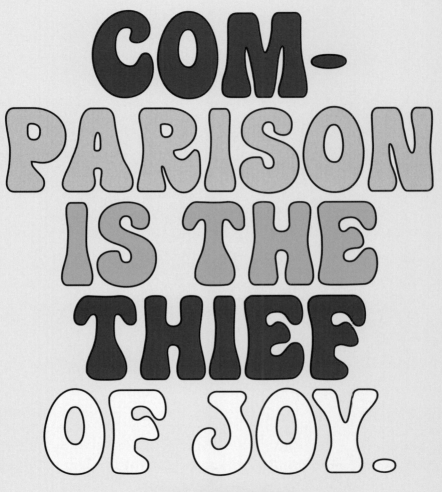

COM-PARISON IS THE THIEF OF JOY.

THEODORE ROOSEVELT

TWO THINGS PREVENT US FROM HAPPINESS: LIVING IN THE PAST AND OBSERVING OTHERS.

UNKNOWN

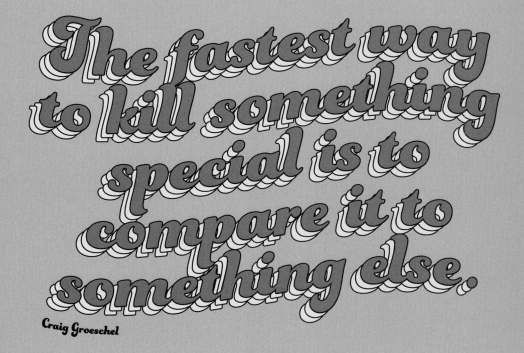

The fastest way to kill something special is to compare it to something else.

Craig Groeschel

STOP TELLING YOURSELF YOU'LL BE HAPPY WHEN YOU HAVE MORE MONEY, OR LOSE 5 POUNDS, OR START DATING SOMEONE. LIFE CANNOT BE PAUSED AND RESUMED WHEN EVERYTHING IS EXACTLY THE WAY YOU WANT IT TO BE. THIS IS LIFE, THIS MOMENT, HAPPENING RIGHT BEFORE YOUR EYES. THE TIME TO DO WHAT YOU WANT TO DO AND BE WHO YOU WANT TO BE IS NOW.

CHRISTIE

3

Change

I Want Things to Change
but Also Remain Exactly the Same

Charles Darwin is once thought to have said "It is not the strongest of species that survive, nor the most intelligent, but the one most responsive to change." And well, that quote makes me feel like I should have been dead a long time ago. To say that I hate change is an understatement. I'm the kind of person who won't upgrade my phone software until I absolutely have to because I'm too attached to the way the old version looks. I also refuse to get anything but the Mexican Tortilla Salad (no beans) at the Cheesecake Factory because if it ain't broke, why fix it? When I leave for a trip, I mourn my bed and daily routine, and when I return from that trip, I miss the hotel room and restaurant food. If your entire life has been a never-ending game of tug-of-war between wanting things to change and improve while also hoping they stay exactly the same—I feel that. It is both a joyous and tragic fact of life that **THE ONLY THING THAT NEVER CHANGES IS THAT THINGS CHANGE.**

So I have decided that instead of spending my time on Earth kicking and screaming when life does not go the way I planned (spoiler: it never does), I will instead focus on strengthening my mind and soul to deal with whatever changes come my way. What I've realized throughout this journey thus far is that my resistance to change stems from my natural human instinct to avoid pain at all costs. However, what I keep reminding myself is that even the most positive changes require a great deal of growth and discomfort at first. Just because it might temporarily hurt doesn't mean it's the wrong decision, and by avoiding change in hopes of keeping myself from possible pain, I also keep myself from possible joy. And I'm just not going to do that anymore. So consider this my formal invitation for you to join me as we say "Bring it on!" to every amazing, horrible, and OMG moment life has to offer. It won't be comfortable, and it won't be easy, but I have a feeling we'll all look back and thank ourselves for getting through the hard stuff because it led us to the most beautiful stuff.

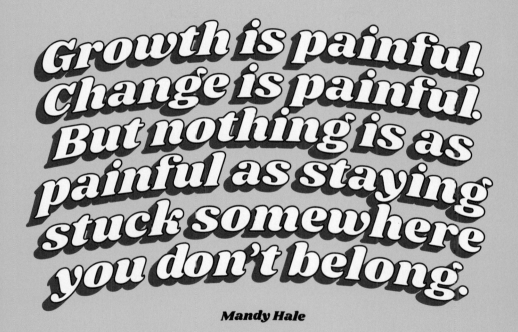

Growth is painful. Change is painful. But nothing is as painful as staying stuck somewhere you don't belong.

Mandy Hale

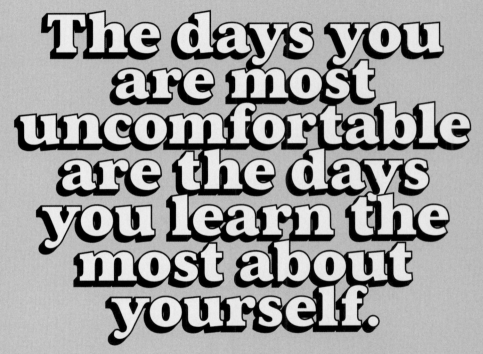

The days you are most uncomfortable are the days you learn the most about yourself.

Mary L. Bean

REMEMBER: GROWING MIGHT FEEL A LOT LIKE BREAKING AT FIRST.

UNKNOWN

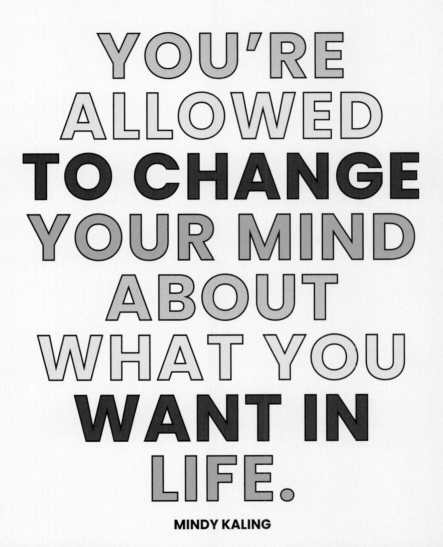

YOU'RE ALLOWED **TO CHANGE** YOUR MIND ABOUT WHAT YOU **WANT IN** LIFE.

MINDY KALING

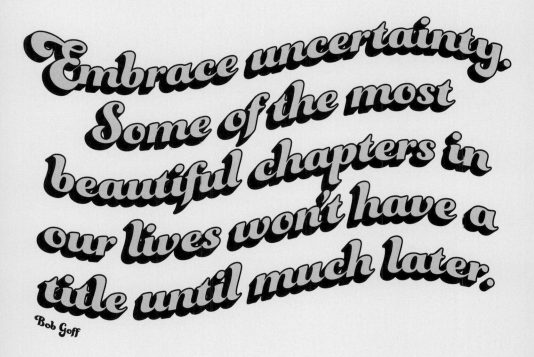

Embrace uncertainty. Some of the most beautiful chapters in our lives won't have a title until much later.

Bob Goff

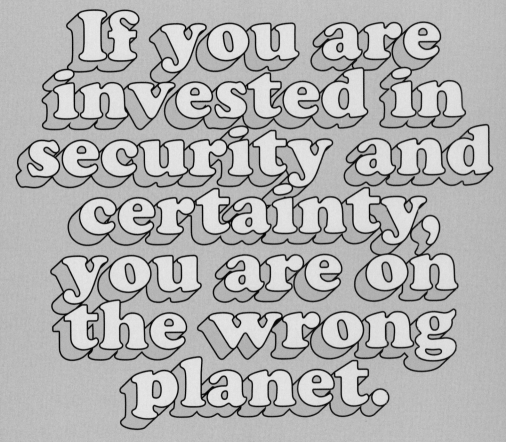

If you are invested in security and certainty, you are on the wrong planet.

Pema Chödrön

NEW BEGINNINGS ARE OFTEN DISGUISED AS PAINFUL ENDINGS.

LAO TZU

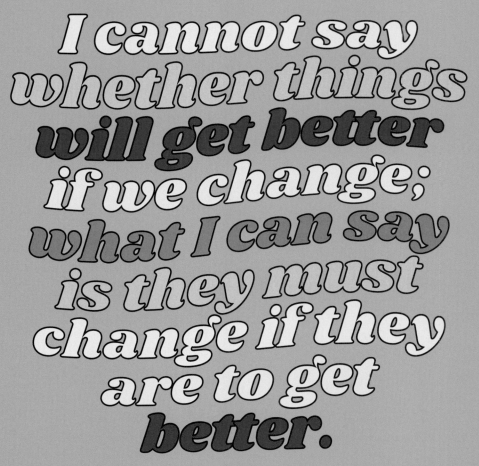

I cannot say
whether things
will get better
if we change;
what I can say
is they must
change if they
are to get
better.

Georg C. Lichtenberg

There is a time
for departure,
even when
there's no certain
place to go.

Tennessee Williams

STOP LOOKING FOR HAPPINESS IN THE SAME PLACE YOU LOST IT.

UNKNOWN

Sometimes the smallest step in the right direction ends up being the biggest step of your life.

Naeem Callaway

You are under no obligation to be the same person you were five minutes ago.

Alan Watts

YOU CAN'T HEAL IN THE SAME ENVIRON- MENT THAT MADE YOU SICK.

UNKNOWN

AND ONCE THE STORM IS OVER, YOU WON'T REMEMBER HOW YOU MADE IT THROUGH, HOW YOU MANAGED TO SURVIVE. YOU WON'T EVEN BE SURE WHETHER THE STORM IS REALLY OVER. BUT ONE THING IS CERTAIN. WHEN YOU COME OUT OF THE STORM, YOU WON'T BE THE SAME PERSON WHO WALKED IN. THAT'S WHAT THIS STORM'S ALL ABOUT.

HARUKI MURAKAMI

4

Sadness

No Number of Funny TikToks
Will Stop These Tears from Flowing

SOMETIMES LIFE JUST SUCKS. People can be mean and selfish, things rarely go the way we want them to, and, to my constant bewilderment, very bad things can happen to really great people. If you've ever felt like there's no motivational quote, rom-com, or funny TikTok that can make life suck any less—I feel that. I could use this little chapter intro to talk about all the things you could do to cheer up and look at the bright side of life, but I haven't found that mentality to be very effective. As much as I (clearly) love positivity, I also recognize that positivity all the time is not productive. There is always hope, and better days are ahead, but that hope for the future does not diminish the difficulties of the present moment. You don't have to "stop being sad" or "get over it." If it hurts, it hurts, and that's okay. Let yourself be sad. Really lean into it. Sometimes I'll even say to myself, "Today has been a very bad day, and that's okay.' Cry if you need to, vent if you want to, and enjoy your

pity party for as long as necessary. Don't allow anyone to belittle your emotions with claims of "oversensitivity" or "overreaction." No matter how big or small your problems may seem to others, they are big to you, and that is all that matters. So there's my not-so-peppy pep talk. Feel what you need to feel, and when you're ready, remind yourself that life is tough, but so are you.

And even if somebody else has it much worse, that doesn't really change the fact that you have what you have. Good and bad.

Stephen Chbosky

JUST BECAUSE THINGS COULD'VE BEEN DIFFERENT DOESN'T MEAN THEY WOULD'VE BEEN BETTER.

UNKNOWN

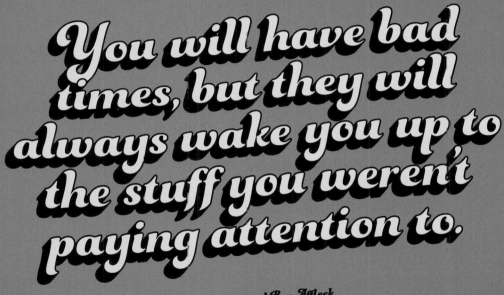

You will have bad times, but they will always wake you up to the stuff you weren't paying attention to.

Matt Damon and Ben Affleck

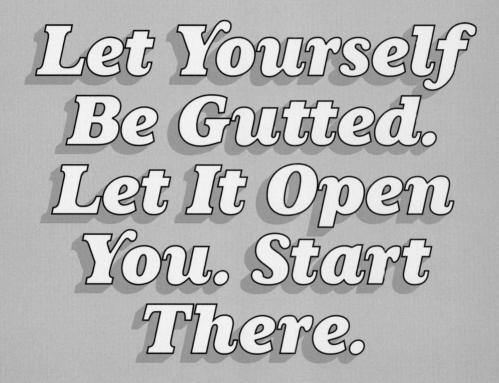

Let Yourself Be Gutted. Let It Open You. Start There.

Cheryl Strayed

RESPECT YOURSELF ENOUGH TO WALK AWAY FROM ANYTHING THAT NO LONGER SERVES YOU, GROWS YOU, OR MAKES YOU HAPPY.

ROBERT TEW

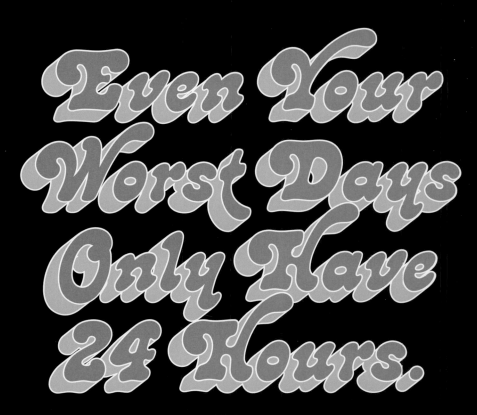

Even Your
Worst Days
Only Have
24 Hours.

Unknown

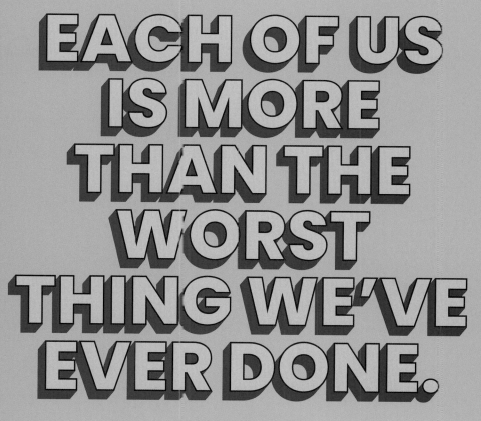

EACH OF US
IS MORE
THAN THE
WORST
THING WE'VE
EVER DONE.

BRYAN STEVENSON

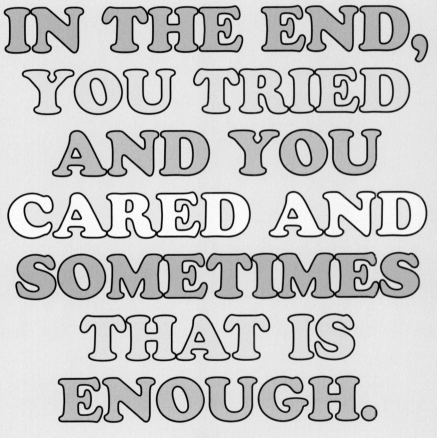

IN THE END,
YOU TRIED
AND YOU
CARED AND
SOMETIMES
THAT IS
ENOUGH.

UNKNOWN

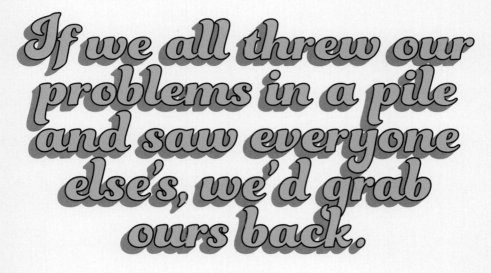

If we all threw our problems in a pile and saw everyone else's, we'd grab ours back.

Regina Brett

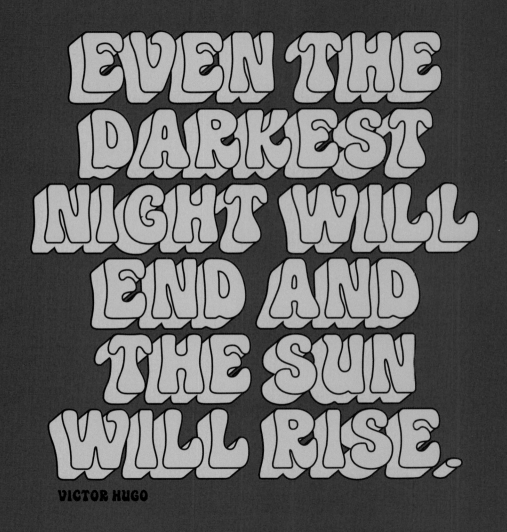

EVEN THE DARKEST NIGHT WILL END AND THE SUN WILL RISE.

VICTOR HUGO

ROCK BOTTOM
WILL TEACH YOU
LESSONS THAT
MOUNTAINTOPS
NEVER WILL.

UNKNOWN

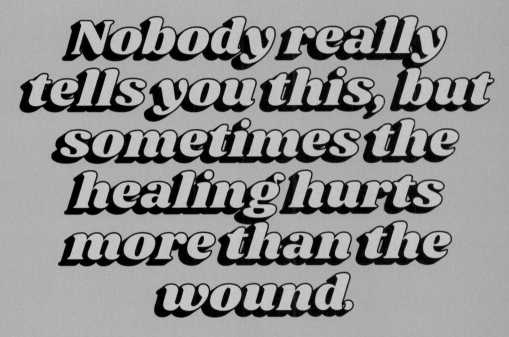

Nobody really tells you this, but sometimes the healing hurts more than the wound.

Unknown

NEVER STOP BEING A GOOD PERSON BECAUSE OF BAD PEOPLE.

UNKNOWN

I wish I could tell you it gets better, but it doesn't get better. You get better.

Joan Rivers

THERE ARE DAYS THAT MUST HAPPEN TO YOU.

WALT WHITMAN

YOU GAIN STRENGTH, COURAGE, AND CONFIDENCE BY EVERY EXPERIENCE IN WHICH YOU REALLY STOP TO LOOK FEAR IN THE FACE. YOU ARE ABLE TO SAY TO YOURSELF, "I LIVED THROUGH THIS HORROR. I CAN TAKE THE NEXT THING THAT COMES ALONG."

ELEANOR ROOSEVELT

5

Confidence

Guac Doesn't Apologize for Being Extra, and Neither Should You

HERE'S THE SAD TRUTH—NOT EVERYONE IS GOING TO LIKE YOU. And here's the happy truth—you don't have to care! Let's do a little exercise: think about the person you are when you're alone, with family, and with different groups of friends. Is that person the same in every scenario? When I stopped to think about this question, I came to the sad realization that I was often making small adjustments to myself to please other people. I would tailor my opinion with one crowd, talk less with another crowd, hide parts of my body with another crowd, and so on. Often, my desire to be liked and accepted was greater than my desire to be true to myself. What I've come to understand, however, is that true confidence means never changing yourself to fit other people. When you are truly confident, you feel secure enough with every inch of your body, every opinion, and every personality trait that you don't need to prove your worth to anyone. Now, you might be asking,

"Well, what about my imperfections? How am I supposed to feel confident when there are so many things about myself that I don't like?" I think the biggest misunderstanding regarding self-love and confidence is that you can only love yourself once you've gotten rid of all of your imperfections, and to that I say, WRONG-O. I hate to be the one to break it to you, but the most confident people in the world also have a million things they don't like about themselves. They've just decided to love and accept themselves *despite* those flaws. You might roll your eyes at this, but I promise that when you embrace and accept every aspect of what makes you *you*, those small "imperfections" will pale in comparison to the incredible human being you have come to love. So let's be known as the people who are unapologetically themselves, no matter who they're around. Let's be known as the people who don't let society's unrealistic standards of perfection prevent them from loving themselves any less. The most beautiful thing about genuine confidence is that it's contagious, and when people see it in others, they get more power to find it in themselves.

You Will Be Too Much for Some People. Those Aren't Your People.

Glennon Doyle

I HAVE A LIMITED AMOUNT OF TIME LEFT ON THIS PLANET, AND I'M NOT GONNA SPEND IT BEING A WATERED-DOWN VERSION OF MYSELF JUST SO PEOPLE CAN LIKE ME.

UNKNOWN

How you make others feel about themselves says a lot about you.

Unknown

SOMETIMES THE BRAVEST, MOST IMPORTANT THING YOU CAN DO IS JUST SHOW UP.

BRENÉ BROWN

THE MOST
POWERFUL YOU
WILL EVER BE IS
WHEN YOU DECIDE
THAT NO OUTSIDE
PERSON OR THING
CAN CONTROL HOW
YOU FEEL ABOUT
YOURSELF.

CHRISTIE

PEOPLE WILL
LOVE YOU.
PEOPLE WILL
HATE YOU.
AND NONE OF
IT WILL HAVE
ANYTHING TO
DO WITH YOU.

ESTHER HICKS

I wish, as well as everybody else, to be perfectly happy; but, like everybody else, it must be in my own way.

Jane Austen

A person who knows what they bring to the table is not afraid to eat alone.

Unknown

REMIND YOURSELF THAT YOU CANNOT FAIL AT BEING YOURSELF.

WAYNE DYER

IT IS NOT YOUR JOB TO PROVE YOU ARE LOVABLE.

CHRISTIE

REPEAT AFTER ME: THAT WAS MY LAST YEAR OF TOLERATING LESS THAN I DESERVE.

UNKNOWN

If outside validation is your only source of nourishment, you will hunger for the rest of your life.

Unknown

The more
you love
yourself,
the less
you need
others to
love you.

Christie

Be so completely yourself that everyone else feels safe to be themselves, too.

Unknown

People at **war** with themselves **will** always cause collateral **damage** in the lives of those around them.

John Mark Green

YOU WOULDN'T WORRY SO MUCH ABOUT WHAT OTHERS THINK OF YOU IF YOU REALIZED HOW SELDOM THEY DO.

ELEANOR ROOSEVELT

WHEN NOBODY ELSE CELEBRATES YOU, LEARN TO CELEBRATE YOURSELF. WHEN NOBODY ELSE COMPLIMENTS YOU, THEN COMPLIMENT YOURSELF. IT'S NOT UP TO OTHER PEOPLE TO KEEP YOU ENCOURAGED. IT'S UP TO YOU. ENCOURAGEMENT SHOULD COME FROM THE INSIDE.

JAY SHETTY

6

Positivity

I'm Confident My Life Won't End Up as Terribly as a *Grey's Anatomy* Season Finale

Let's clear the air before diving in here: this chapter is not about prescribing a daily dose of toxic positivity to anyone. Trust me, when something bad happens in my life, the last thing I want to hear is Jessica Day telling me to "Look at the bright side of things." That being said, that's usually some pretty sound advice. If you've ever found that the more you look for the good in yourself and those around you, the more of it there is—I feel that. It's advice you never want to hear, but **YOUR HAPPINESS HAS VERY LITTLE TO DO WITH WHAT'S HAPPENING IN YOUR LIFE AND EVERYTHING TO DO WITH WHAT YOU THINK ABOUT WHAT'S HAPPENING.** I, and probably every single one of you, have had many a time when I have been powerless to change a situation (even though I've tried *reeaaallly* hard), so I've been left with only one, bleak option: to change my mindset. I know, you're probably sitting here like, "I don't want to hear it! I'm not

listening!" but hear me out. I know changing your mindset is far more difficult than any motivational quote makes it seem, especially when life throws things at you that seem unbearable and unfair. Having the mental strength to find hope and meaning throughout life's most difficult moments is a superpower that few possess, but, thankfully, all can achieve it with enough introspection and practice. One of the most powerful methods I've found for increasing positive vibes in my life is to focus on what I do have instead of obsessing over what's going wrong—or in other words, staying grateful. Don't worry, I haven't included a page to write down three things you're grateful for, but I would recommend doing that either on paper, to a friend, or in your head, every day. Finding even three things might seem hard some days, but you'd be surprised how this small daily activity can rewire your brain. As you take time out of your day to focus on the good, I promise there will be more of it to see.

AND I URGE YOU
TO PLEASE NOTICE
WHEN YOU ARE
HAPPY, AND
EXCLAIM OR
MURMUR OR
THINK AT SOME
POINT, "IF THIS
ISN'T NICE, I DON'T
KNOW WHAT IS."

KURT VONNEGUT JR.

At the end of the day, you can either focus on what's tearing you apart or what's holding you together.

Unknown

What a wonderful thought it is that some of the best days of our lives haven't even happened yet.

Anne Frank

It isn't what you have or who you are or where you are or what you are doing that makes you happy or unhappy. It is what you think about it.

Dale Carnegie

STOP THINKING ABOUT WHAT COULD GO WRONG, AND START THINKING ABOUT WHAT COULD GO RIGHT.

UNKNOWN

Don't Wait Until Everything Is Perfect to Be Happy.

Christie

TALK ABOUT YOUR BLESSINGS MORE THAN YOU TALK ABOUT YOUR PROBLEMS.

UNKNOWN

Amazing things come into our lives when we are paying attention.

Anne Lamott

THE KEY TO HAPPINESS IS LETTING EACH SITUATION BE WHAT IT IS INSTEAD OF WHAT YOU THINK IT SHOULD BE.

MANDY HALE

Never let the things you want make you forget the things you have.

Sanchita Pandey

Gratitude helps you fall in love with the life you already have.

Unknown

I have found that most people are about as happy as they make their minds up to be.

Abraham Lincoln

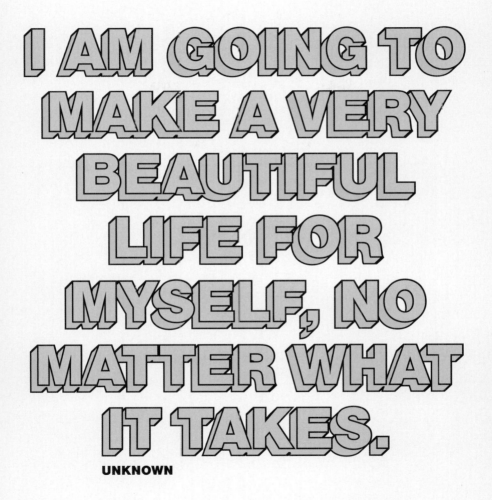

I AM GOING TO MAKE A VERY BEAUTIFUL LIFE FOR MYSELF, NO MATTER WHAT IT TAKES.

UNKNOWN

I AM IN CHARGE OF HOW I FEEL, AND TODAY I AM CHOOSING HAPPINESS.

UNKNOWN

The little things? The little moments? 'They aren't little.

Jon Kabat-Zinn

Staying positive doesn't mean you have to be happy all the time. It means that even on the hard days, you know better ones are coming.

Unknown

ATTITUDE IS A CHOICE.
HAPPINESS IS A CHOICE.
OPTIMISM IS A CHOICE.
KINDNESS IS A CHOICE.
GIVING IS A CHOICE.
RESPECT IS A CHOICE.
WHATEVER CHOICE YOU MAKE MAKES YOU. CHOOSE WISELY.

ROY T. BENNETT

Anxiety

I'm Fine—I Mean *Michael Scott One Day After Starting the Michael Scott Paper Company*—I'm FINE

IF MY ANXIETY WERE AN ITEM, IT WOULD BE A DECORATIVE PILLOW—IT SERVES ABSOLUTELY NO PURPOSE, BUT I FEEL LIKE I NEED IT. Despite my most sincere efforts, I have always been the kind of person who assumes the worst will happen and prepares for my impending doom before a situation even resolves itself. *Patience* is just not in my vocabulary. If you obsess and assume and freak out until you know FOR SURE what's going to happen—I feel that. And if that worrying has literally never helped any situation in your life—I also feel that. Now, I've come to accept the fact that I will never be one of those people who can be "chill" when things go wrong or when I'm unsure of the future. But I'm on a journey to try to be a little bit "more chill." That journey has begun by understanding that anxiety will never change the outcome of a situation. It will never make hard times easier or help make decisions faster or find something quicker. It won't make

people like you or get you into that school or get you that promotion. The future will never be changed by your anxiety, but your present will. Worrying does nothing but rob your joy from the present moment in anticipation of something that may never even happen. And if the worst really does come to pass, then you suffer through it twice. Trust me, I wish I could worry my way into a life that goes 100 percent according to plan, but that's just not the name of the game. So perhaps from now on, we tap into our higher, "chiller" selves; let go of the things we cannot change; and embrace the only thing we have for sure—the present moment.

WORRYING DOES NOT TAKE AWAY TOMORROW'S TROUBLES. IT TAKES AWAY TODAY'S PEACE.

RANDY ARMSTRONG

It is when our plans go "wrong" that wonderful, unforeseen things are allowed to occur.

Unknown

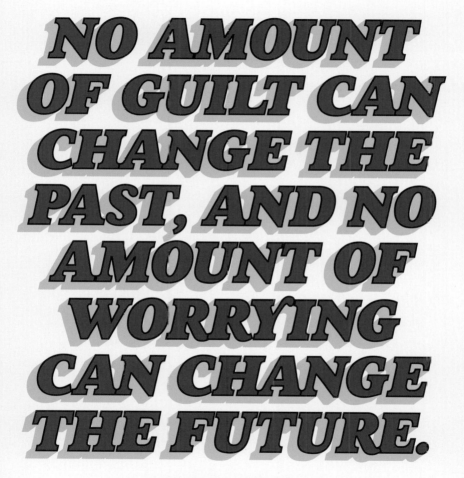

NO AMOUNT OF GUILT CAN CHANGE THE PAST, AND NO AMOUNT OF WORRYING CAN CHANGE THE FUTURE.

UMAR IBN AL-KHATTAB

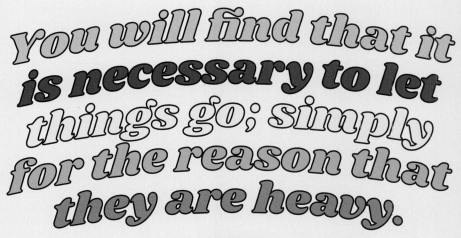

You will find that it *is necessary to let* things go; simply for the reason that they are heavy.

C. JoyBell C.

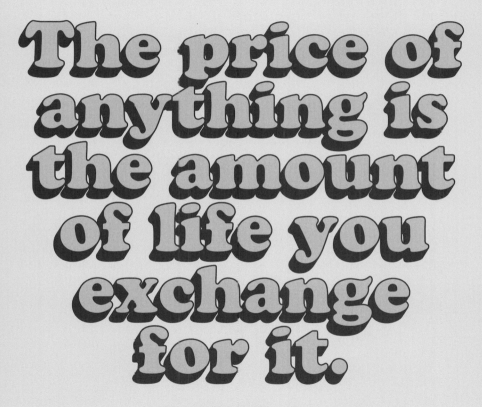

The price of anything is the amount of life you exchange for it.

Henry David Thoreau

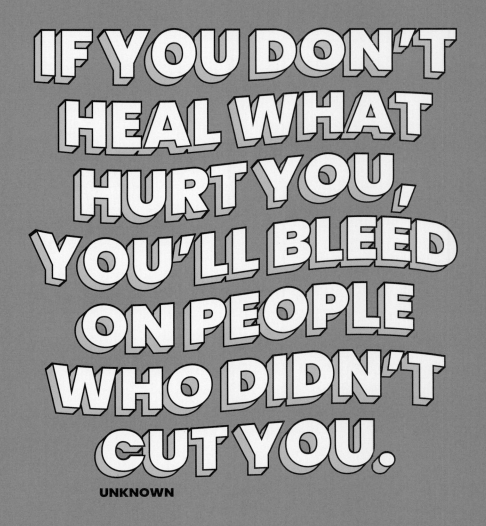

IF YOU DON'T HEAL WHAT HURT YOU, YOU'LL BLEED ON PEOPLE WHO DIDN'T CUT YOU.

UNKNOWN

You can't calm the storm ... so stop trying. What you can do is calm yourself. The storm will pass.

Buddha

YOU DON'T HAVE TO FIGURE IT ALL OUT RIGHT NOW. JUST DO THE NEXT RIGHT THING.

CHRISTIE

Worry is like a rocking chair: it gives you something to do, but it won't get you anywhere.

Erma Bombeck

YOU CAN'T GO BACK AND CHANGE THE BEGINNING, BUT YOU CAN START WHERE YOU ARE AND CHANGE THE ENDING.

C. S. LEWIS

WORRY OFTEN GIVES A SMALL THING A BIG SHADOW.

SWEDISH PROVERB

ONE OF THE HAPPIEST MOMENTS IN LIFE IS WHEN YOU FIND THE COURAGE TO LET GO OF WHAT YOU CANNOT CHANGE.

LORI DESCHENE

Not everything that weighs you down is yours to carry.

Unknown

There were many terrible things in my life and most of them never happened.

Michel de Montaigne

YOU'RE BRAVER THAN YOU BELIEVE, AND STRONGER THAN YOU SEEM, AND SMARTER THAN YOU THINK.

A. A. MILNE

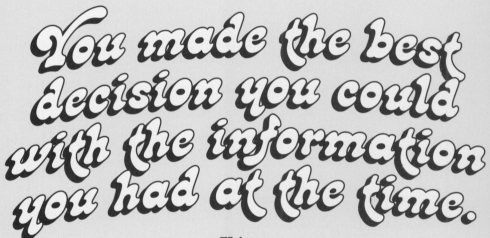

You made the best decision you could with the information you had at the time.

Unknown

Our anxiety does not come from thinking about the future but from wanting to control it.

Kahlil Gibran

8

Self-Love

This New Face Mask
Isn't Going to Use Itself

In my opinion, self-love presents itself in two ways: physical and mental. If your physical self-love includes a Peloton ride, a fried chicken sandwich, and a guilty-pleasure Bravo show—I feel that. It may also look like meditation, a long bath, some new PJs, or your favorite candy. There are an innumerable number of things you can do, watch, buy, and eat that will surely lift your spirits and bring you (temporary) joy. Now, unfortunately, **THAT NEW MANICURE MEANS NOTHING IF YOU AREN'T KIND TO YOUR MIND.** It's easy to draw a bath or order your favorite take-out, but how easy is it to forgive yourself for not being where you thought you'd be at your age or accept that you've done your best for the day and stop replaying hurtful scenarios in your mind? How easy is it to understand that you are lovable even if some people don't like you and that you are valuable even if some people don't see your value? You can buy every face mask in the world, but none of them

will be able to show you that you are worthy of every good thing until you start believing it yourself. A piece of self-love advice from the iconic Brené Brown recommends that you speak to yourself like you would to a friend or loved one. If they were struggling, would you tell them it was because they weren't good enough, weren't strong enough, or had made too many mistakes in their past? Or would you encourage them to keep going, keep trying, and be patient with themselves in the process? I would hope you would say the latter, so now say the same to yourself. Oh, and also eat the fried chicken sandwich. You're doing great.

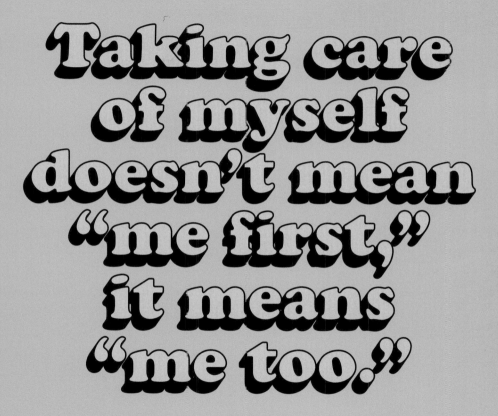

Taking care of myself doesn't mean "me first," it means "me too."

L. R. Knost

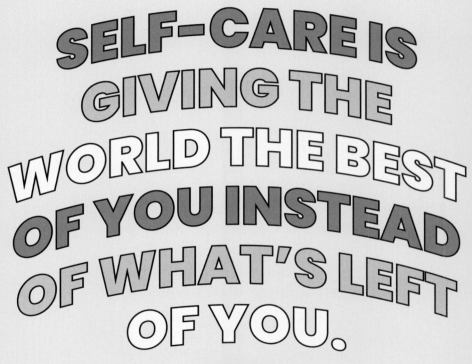

SELF-CARE IS GIVING THE WORLD THE BEST OF YOU INSTEAD OF WHAT'S LEFT OF YOU.

KATIE REED

"DOING YOUR BEST" DOES NOT MEAN PUSHING YOURSELF TO THE POINT OF A MENTAL BREAKDOWN.

UNKNOWN

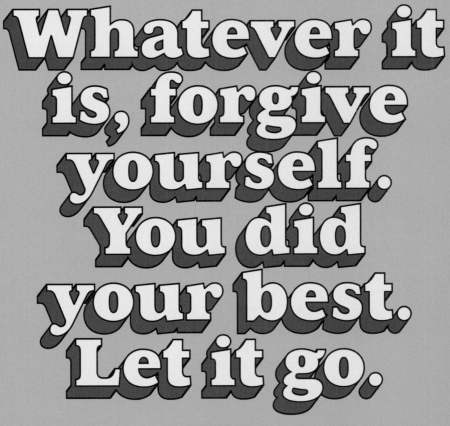

Whatever it is, forgive yourself. You did your best. Let it go.

Will Bowen

Always go out of your way to be nice to somebody, and never forget that you're somebody, too.

Christie

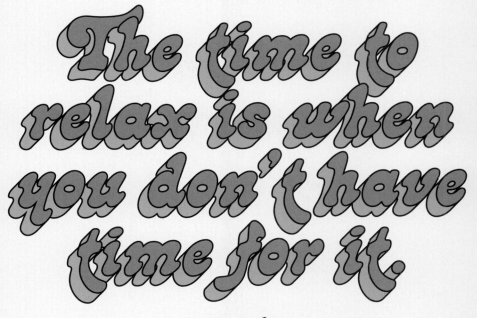

The time to relax is when you don't have time for it.

Sydney J. Harris

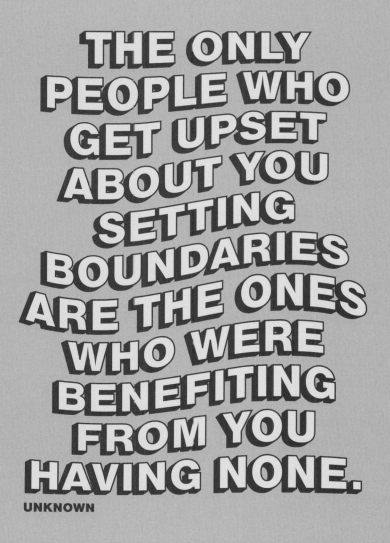

THE ONLY
PEOPLE WHO
GET UPSET
ABOUT YOU
SETTING
BOUNDARIES
ARE THE ONES
WHO WERE
BENEFITING
FROM YOU
HAVING NONE.

UNKNOWN

Some days, doing "the best we can" may still fall short of what we would like to be able to do, but life isn't perfect—on any front—and doing what we can with what we have is the most we should expect of ourselves or anyone else.

Fred Rogers

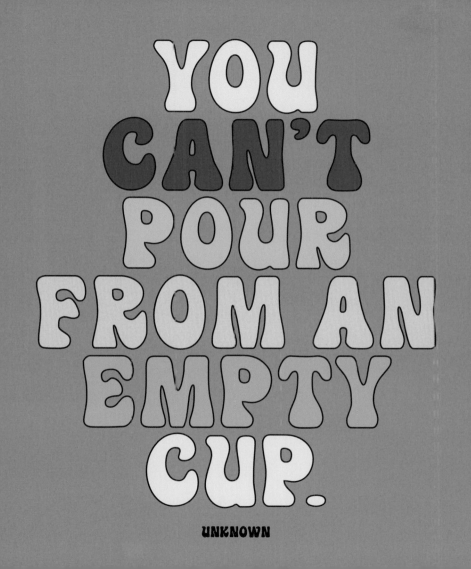

YOU CAN'T POUR FROM AN EMPTY CUP.

UNKNOWN

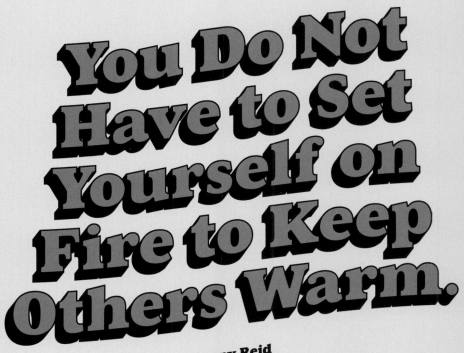

You Do Not Have to Set Yourself on Fire to Keep Others Warm.

Penny Reid

DESTROY THE IDEA THAT YOU HAVE TO BE CONSTANTLY WORKING OR GRINDING TO BE SUCCESSFUL. EMBRACE THE CONCEPT THAT REST, RECOVERY, AND REFLECTION ARE ESSENTIAL PARTS OF THE PROGRESS TOWARD A SUCCESSFUL, HAPPY LIFE.

UNKNOWN

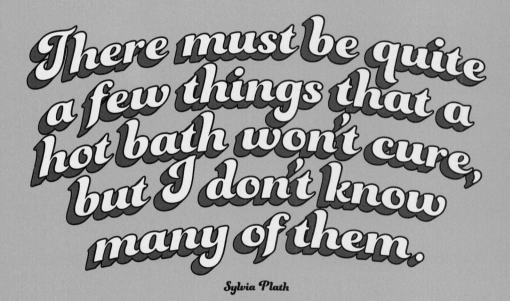

There must be quite a few things that a hot bath won't cure, but I don't know many of them.

Sylvia Plath

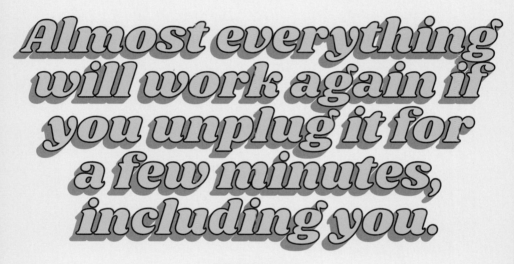

Almost everything will work again if you unplug it for a few minutes, including you.

Anne Lamott

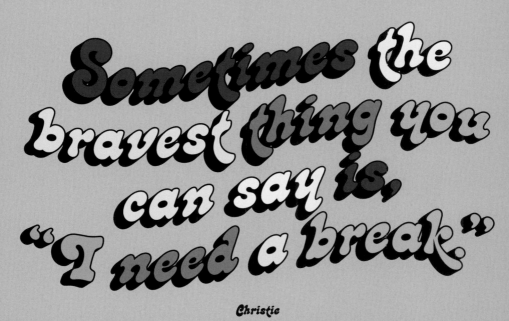

Sometimes the bravest thing you can say is, "I need a break."

Christie

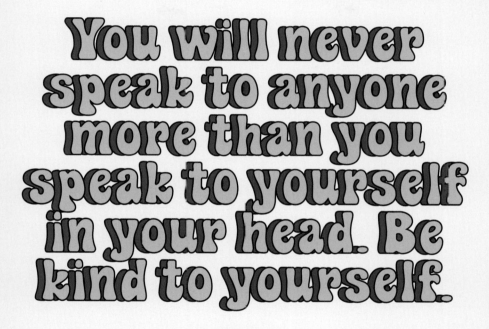

You will never speak to anyone more than you speak to yourself in your head. Be kind to yourself.

Unknown

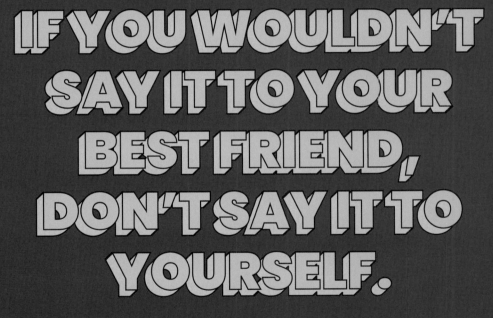

IF YOU WOULDN'T SAY IT TO YOUR BEST FRIEND, DON'T SAY IT TO YOURSELF.

CHRISTIE

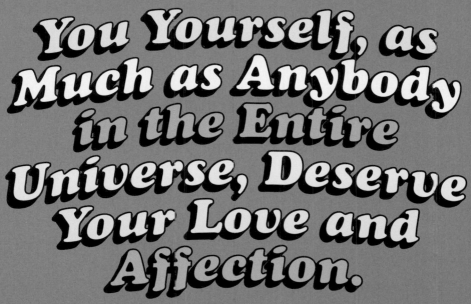

You Yourself, as Much as Anybody in the Entire Universe, Deserve Your Love and Affection.

Buddha

9

Loneliness

Netflix? Check. New Anthropologie Candle? Check. Fuzzy Blanket? Check. Gang's All Here.

If you've ever felt like you have so many friends and no friends all at the same time—I feel that. Sure, some people like going out more and some like staying in, but no matter how much of a party animal or homebody you are, **WE'VE ALL HAD TIMES WHEN WE'VE FELT LIKE THE LAST PERSON ON *SURVIVOR*.** Maybe you've tried texting everyone in the group chat and got no response, or you've gone through your contacts list and come up empty-handed. The fact is, making friends is hard; making good friends is even harder; and making reliable, loyal friends is the hardest. People are complicated, and no matter how much they love you or how close you are, everyone comes with an extra-large duffel bag of things they don't talk about. Don't beat yourself up when people aren't responding or when it seems like everyone is out doing fabulous things except you. The way people treat you says nothing about you and everything about them. What's most important in

these situations is to recognize that the best, most important company you will ever have is your own. People who know they are valuable, loved, and whole, with or without anyone around them, enjoy their alone time just as much as they do their social time. A party of one can be the most fun party there is, if you take time to get to know yourself and discover what you truly enjoy doing. Lonely doesn't have to be a bad thing. Being happy with others, and just as happy alone, is a powerful, mature place to be. So the next time you're feeling down and assuming your text messages just haven't been going through, consider it an opportunity to become better friends with the one person you will most definitely spend the rest of your life with—yourself.

I DON'T CHASE PEOPLE ANYMORE. I LEARNED THAT I'M HERE, AND I'M IMPORTANT. I'M NOT GOING TO RUN AFTER PEOPLE TO PROVE THAT I MATTER.

STEVE MARABOLI

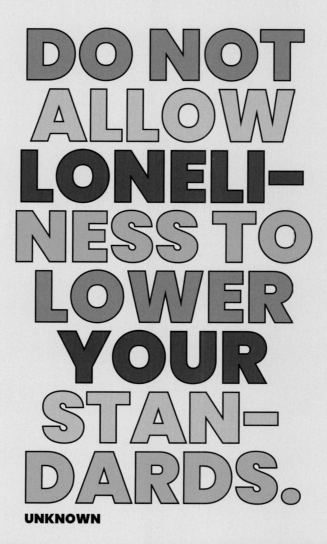

DO NOT ALLOW LONELI-NESS TO LOWER YOUR STAN-DARDS.

UNKNOWN

I used to think the worst thing in life was to end up all alone. It's not. The worst thing in life is ending up with people who make you feel all alone.

Bobcat Goldthwait

THE GREATEST THING IN THE WORLD IS TO KNOW HOW TO BELONG TO ONESELF.

MICHEL DE MONTAIGNE

You are important and special and loved, even when your mind tells you you're not.

Unknown

Just because
you feel alone
does not mean
you are.

Christie

YOUR RELATIONSHIP WITH YOURSELF SETS THE TONE FOR EVERY OTHER RELATIONSHIP YOU HAVE.

ROBERT HOLDEN

BREATHE.
IT'S JUST
A BAD
DAY, NOT
A BAD
LIFE.

KHALID

You are helpful, and you are loved, and you are forgiven, and you are not alone.

John Green

Often the best gift you can give yourself is time alone—some time to ask your questions and listen quietly for the answers.

Katrina Mayer

You're not selfish for wanting the same energy you give.

Unknown

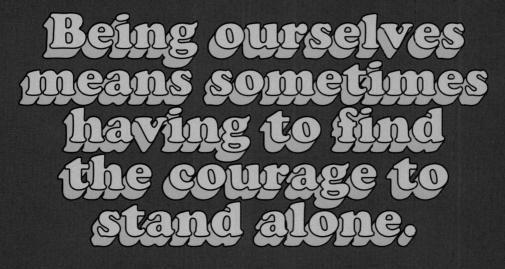

Being ourselves means sometimes having to find the courage to stand alone.

Brené Brown

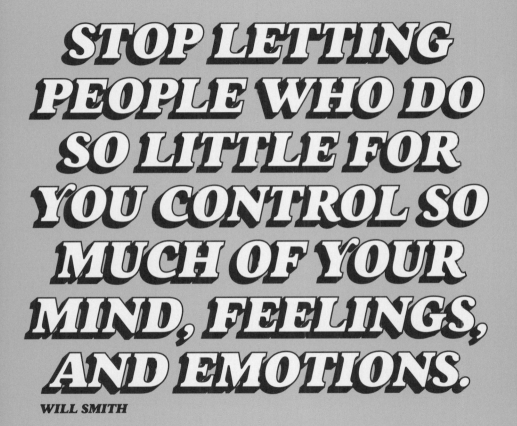

STOP LETTING PEOPLE WHO DO SO LITTLE FOR YOU CONTROL SO MUCH OF YOUR MIND, FEELINGS, AND EMOTIONS.

WILL SMITH

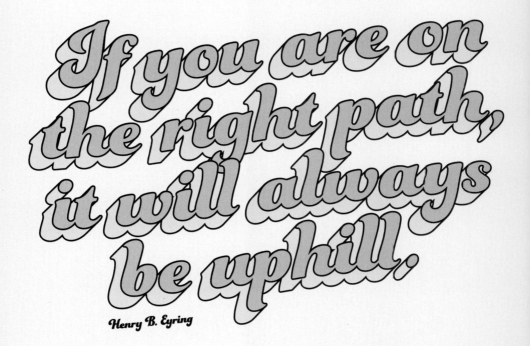

If you are on the right path, it will always be uphill.

Henry B. Eyring

FOR BEAUTIFUL EYES, LOOK FOR THE GOOD IN OTHERS; FOR BEAUTIFUL LIPS, SPEAK ONLY WORDS OF KINDNESS; AND FOR POISE, WALK WITH THE KNOWLEDGE THAT YOU ARE NEVER ALONE.

AUDREY HEPBURN

10

Love

Alexa, Play "Lover"
by Taylor Swift on Repeat

I'll start off by saying that I met my husband at seventeen years old, so I'm not the best person to be giving dating advice. HOWEVER, meeting my future spouse as a teenager certainly did not mean I was spared from crying on my bedroom floor or obsessing over the time it took for him to text me back. **IF YOU'VE EVER ASKED THEM WHO THAT PERSON IN THEIR CONTACTS LIST WAS OR STALKED THEIR SOCIAL MEDIA ON A DAILY BASIS—I FEEL THAT.** The fact is, any relationship, whether romantic or platonic, whether you meet at fifteen or fifty, or whether you're married or dating, is complicated AF. And should we be shocked by that fact? Most of us can't even figure out who we are, much less worry about figuring out someone else as well. As difficult as it may be to find "our people," and as important as it is to learn to be happy on our own, there is no doubt that the quality of our lives will always be intrinsically related to the quality of our

relationships. Yes, you are 100 percent whole and valuable and capable completely on your own, but it never hurts to be surrounded by people who remind you of that. From my almost a decade of being in a relationship with someone who I'm pretty sure thinks I'm the Queen of England, I will offer some subjective advice on the matter of dating and love: 1) Do not allow yourself to ever think that toxic, manipulative, unreciprocated love is the best you can get. Have enough confidence in who you are to know without a doubt that you deserve someone who treats you like the rarest, most beautiful thing in the world. 2) If someone wants to be with you, you'll know it. A relationship should never leave you guessing where you stand with someone. Like me at the Cheesecake Factory, they should know what they want. 3) The right relationship will make you feel more like yourself. It will allow you to learn new things about yourself, recognize more of your potential, aspire to new goals, and go easy on yourself when necessary. There is nothing more beautiful than healthy love, and that's what I wish for each of you reading this book. We can do amazing things alone, but let's never forget that we don't have to.

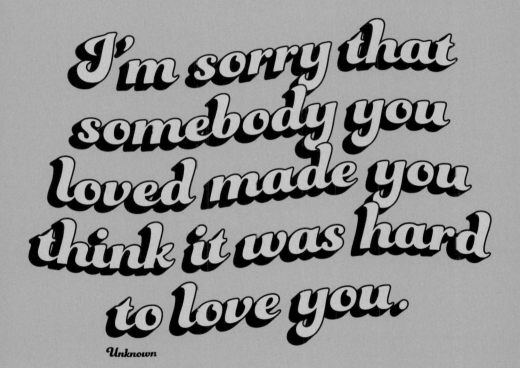

I'm sorry that somebody you loved made you think it was hard to love you.

Unknown

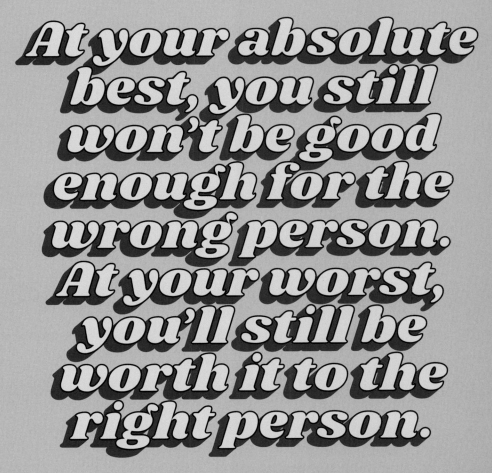

At your absolute best, you still won't be good enough for the wrong person. At your worst, you'll still be worth it to the right person.

Karen Salmansohn

It's like coming home after a long trip. That's what love is like. It's like coming home.

Piper Kerman

We would all be a little better off if we heard "I love you" a little more.

Christie

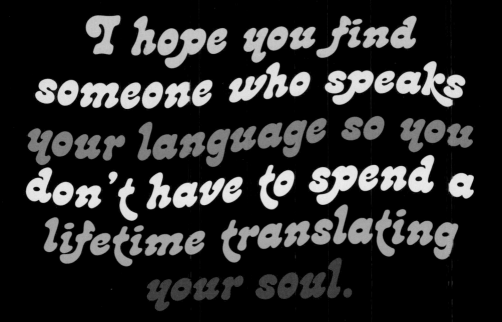

I hope you find someone who speaks your language so you don't have to spend a lifetime translating your soul.

Dr. Thema Bryant-Davis

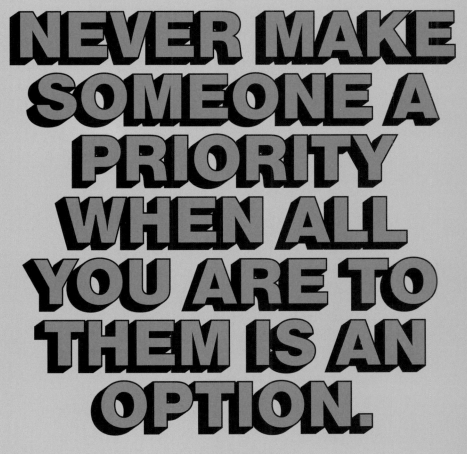

NEVER MAKE SOMEONE A PRIORITY WHEN ALL YOU ARE TO THEM IS AN OPTION.

MAYA ANGELOU

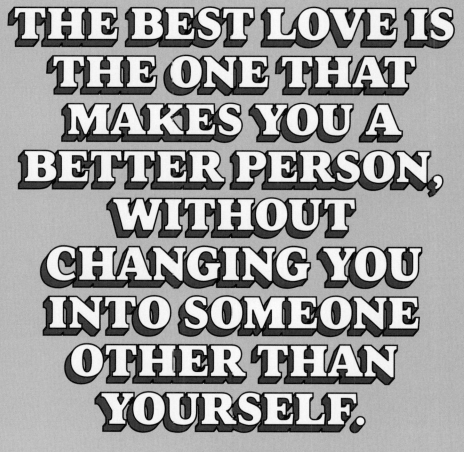

THE BEST LOVE IS THE ONE THAT MAKES YOU A BETTER PERSON, WITHOUT CHANGING YOU INTO SOMEONE OTHER THAN YOURSELF.

UNKNOWN

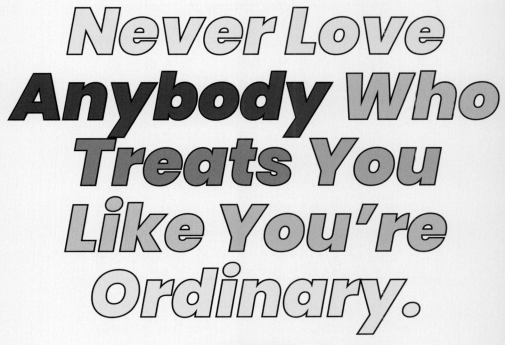

Never Love Anybody Who Treats You Like You're Ordinary.

Oscar Wilde

You are lovable, even if not everybody loves you.

Christie

It's not our job to fix people. It's our job to love them even while they are broken.

Dave Willis

BE WITH SOMEONE WHO ALWAYS WANTS TO KNOW HOW YOUR DAY WAS.

UNKNOWN

I'M SELFISH, IMPATIENT, AND A LITTLE INSECURE. I MAKE MISTAKES, I AM OUT OF CONTROL AND AT TIMES HARD TO HANDLE. BUT IF YOU CAN'T HANDLE ME AT MY WORST, THEN YOU SURE AS HELL DON'T DESERVE ME AT MY BEST.

MARILYN MONROE

You should never find yourself having to convince or beg someone to treat you the way you deserve to be treated.

Unknown

Of course I am not worried about intimidating men. The type of man who will be intimidated by me is exactly the type of man I have no interest in.

Chimamanda Ngozi Adichie

Haruki Murakami

SOMETIMES YOU HAVE TO FORGET HOW YOU FEEL AND THINK OF WHAT YOU DESERVE.

UNKNOWN

THERE'S NOTHING MORE INTIMATE IN LIFE THAN SIMPLY BEING UNDERSTOOD. AND UNDERSTANDING SOMEONE ELSE.

BRAD MELTZER

Acknowledgments

I am grateful for the writers, artists, actors, and thinkers who have taken the time to put the human experience into words. Your messages have transformed these pages, and my life.

I am grateful for the millions of people online who have given me a voice that I never thought I would have, and who have supported me and my dreams, without even knowing me.

I am grateful for Courtney Paganelli at Levine Greenberg Rostan, who has answered every text message within five minutes and patiently guided me through this entire process.

I am grateful for Lauren Appleton and the entire team at TarcherPerigee, who took a chance on an "influencer" writer and believed in the value that I would bring to people's bookshelves and lives.

I am grateful for all of my friends who have supported me on this journey and who have believed in me, even when I wasn't sure that I believed in myself.

I am grateful for my parents, siblings, and family, whose loyalty, support, and love I have never had to question, and who have always made me feel like I belonged.

Lastly, I am forever grateful for my husband, and very best friend, who has been there for me through all of the ugly parts. You've made every beautiful part possible.

About the Author

Christina Scotch never thought she would be writing an "About the Author" excerpt. She is a graphic designer and the founder of Quotes by Christie, a social media presence and brand with over one million Instagram followers. After growing up in Maryland, Christina moved to Utah, where she graduated with a bachelor's degree in public relations from Brigham Young University. She is currently based in Washington, DC, where she manages Quotes by Christie and works as a freelance graphic designer and marketing consultant. Christina loves to cook food, bake food, watch videos and shows about food, and try different restaurants. She also loves discovering new TV shows, traveling to places with cool castles, and being with people who make her forget to check her phone. Christina really hopes that people like this book, but if not, she had a lot of fun making it.